Surrey Artist of the Year 2017

30 September – 11 November

Organised by New Ashgate Gallery in partnership with Surrey Arts.

The competition is supported by Patricia Baines Trust.

Surrey Life magazine has a monthly section dedicated to the local art scene and is the official media partner of the competition.

New Ashgate Gallery
Waggon Yard
Farnham
Surrey GU9 7PS

Editor: Camilla Dingee

Cover Image: Ali Tomlin, *Narrow necked bottle red & black*, thrown porcelain.

All rights reserved. No part of this publication may be reproduced, stored in retrieval systems, or transmitted in any other form.

Shortlist:

Adam Aaronson

Jo Aylwin

Naomi Beevers

Mary Branson

Alex Freeman

Emma Godden

Niki Hearnshaw

Christine Hopkins

Su Jameson

Jule Mallett

Katie Netley

Alison Orchard

Ali Tomlin

Celebrating the talent in the region

The Surrey Artist of the Year Award celebrates the great variety of inspirational and creative talent in the region. The prize is in its 9th year and was established following a partnership between New Ashgate Gallery and Surrey Artists' Open Studios. It also enables the artists to find new audiences and to develop a relationship with a professional gallery.

We work with the public. The selection of artists and makers for the exhibition is a democratic process. The gallery does not curate the exhibition – we invite you to choose. Votes were counted from Surrey Artists' Open Studios summer event and the artists with the most votes have been invited to showcase their work as part of the Surrey Artist of the Year competition at the New Ashgate Gallery. The public is asked to vote again during the show to choose their three favourite artists. The votes cast by visitors and a panel of judges will decide the Surrey Artist of the Year 2017. The winning artist will be announced at a presentation on 20 October and awarded a solo exhibition at the New Ashgate Gallery as well as a cash prize of £1,000.

The Surrey Artist of the Year competition is an important part of our mission as a charity. The New Ashgate Gallery Trust is dedicated to promote and champion the best contemporary art and craft and to provide an unparalleled resource in Farnham, Surrey and beyond. We raise aspirations and inspire excellence. The exhibition enables us to support and promote emerging and established artists and makers. It also coincides with Farnham's Craft Month in October. Contact us to find out about our community workshops and professional practice seminars.

I would like to thank our partners, Surrey Arts and the Surrey Life magazine, that have championed our partnership over the years. We would also like to thank the Patricia Baines Trust – the financial support of the Trust has made this project flourish year after year.

I hope that you enjoy the exhibition and enjoy the voting.

Dr Outi Remes
Gallery Director
New Ashgate Gallery Trust

Surrey Artists' Open Studios

Surrey Artists' Open Studios is a county-wide membership scheme, offering the public direct access to artists and makers during an annual event in June, as well as offering artists a range of other benefits including specialist training and professional development. The scheme is thriving with over 370 members, 266 of whom participated in Open Studios this year, and with about 15,500 visitors during two weeks in June.

Artists' Open Studios vary enormously, with individual artists opening their studios to the public, as well as large groups of artists exhibiting and demonstrating together. Artists often make the most of their settings, offering a chance to see inside some really interesting buildings or setting their work in beautiful gardens. But whatever their circumstances they all have one thing in common; they offer an opportunity for the public to see the work being made, to understand the materials and processes involved, and to talk directly with the artist about what inspires them.

In 2009, the Surrey Artist of the Year competition was set up in partnership with the New Ashgate Gallery. This enables the public to vote for their favourite artist during their visits to Open Studios, with the most popular receiving an invitation to exhibit work at the gallery. This helps to raise the profile of Surrey based artists as well as providing them with professional development and support to build an audience for their work. This year we were pleased to be able to offer online voting for our visitors.

Our partnership with the New Ashgate Gallery, provides a highly valued opportunity for artists to work with a contemporary art and craft gallery to develop their practice and promote their work.

Jane McGibbon
Surrey Artists' Open Studios Coordinator

The Artists

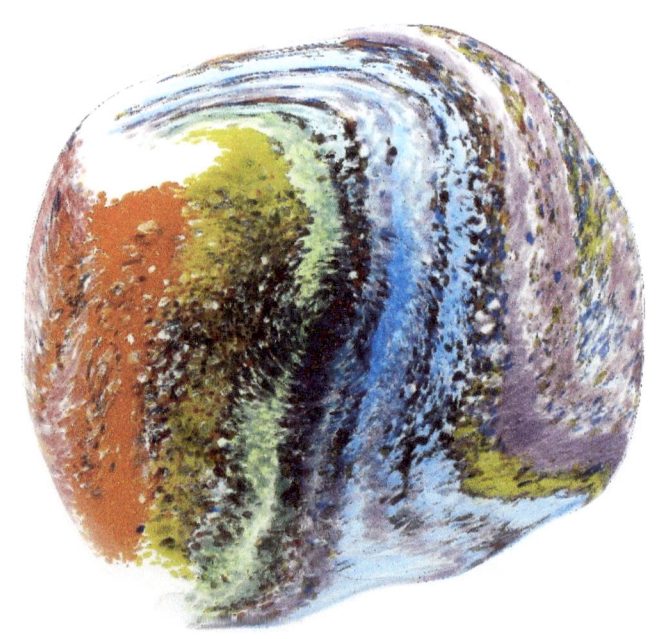

Adam Aaronson

Adam's love affair with glass began almost 40 years ago and his passion for this most unpredictable and seductive of artistic mediums remains undimmed today.

His artwork is inspired by the ceaseless mutability of light on the landscape, sky and water, with the idea of change as a continual presence also a major theme.

Glass is the ideal medium to express these concepts since its properties are inherently mutable, not only in its molten state but also in the way the play of light creates endless nuances in the finished piece. At Adam Aaronson Glass Studio in Surrey, he creates his artwork and teaches glassblowing courses for beginners.

I think of my work as a story of surface and form. Each blown glass artwork is a canvas, depicting the landscape in a variety of abstracted ways.

Adam is based in West Horsley.

Image: *Rainbow Plate*, hand-blown glass.

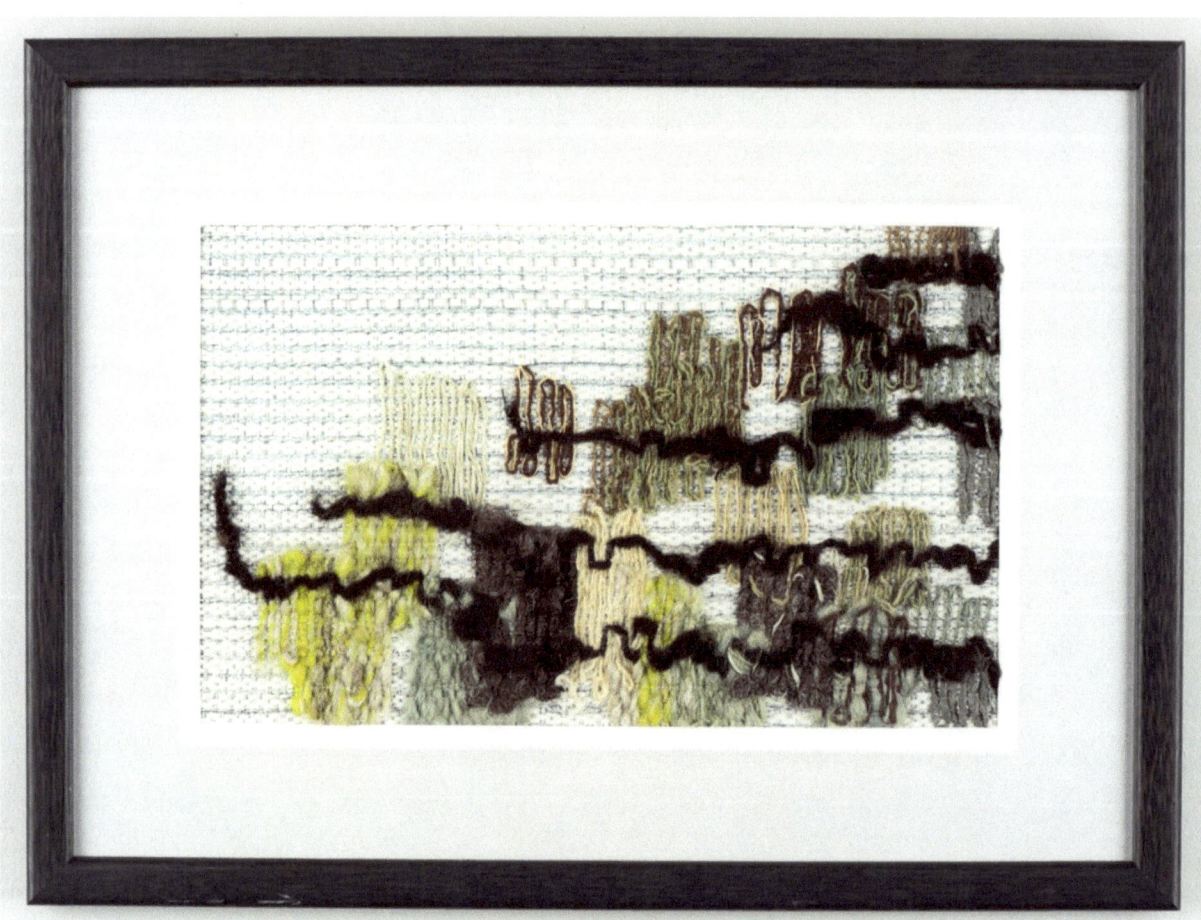

Jo Aylwin

Jo is a hand weaver and textile artist. Jo uses the structure and form inherent to weaving as boundaries that can be pushed to create abstract images. Her work is also a response to the fibres which are used and the choice of fibre will reflect on what is being explored at the time. Most of Jo's works are of a decorative nature and include wall hangings and framed pieces which are for hanging in a domestic or business environment.

Jo currently has two main bodies of work, Aphrodite's Girdle and TTM. The Aphrodite's Girdle series are inspired by Neolithic "Venus" figures and their decoration. These early representations of what is essentially feminine inform the works in this group, which are largely spontaneous, captured moments. Related to these are the very different TTM works which are abstracted pictorial pieces based on natural phenomena. These too capture a point in time, but are seeking a still point of reflection rather than an instance of energy.

I am interested in the boundaries that can be pushed, from which abstracted images interpreting natural phenomena can be produced.

Jo is based in Farnham

Image: *Pines*, framed piece, woven linen, cotton, wool, 2016. Photo: Matthew Burch.

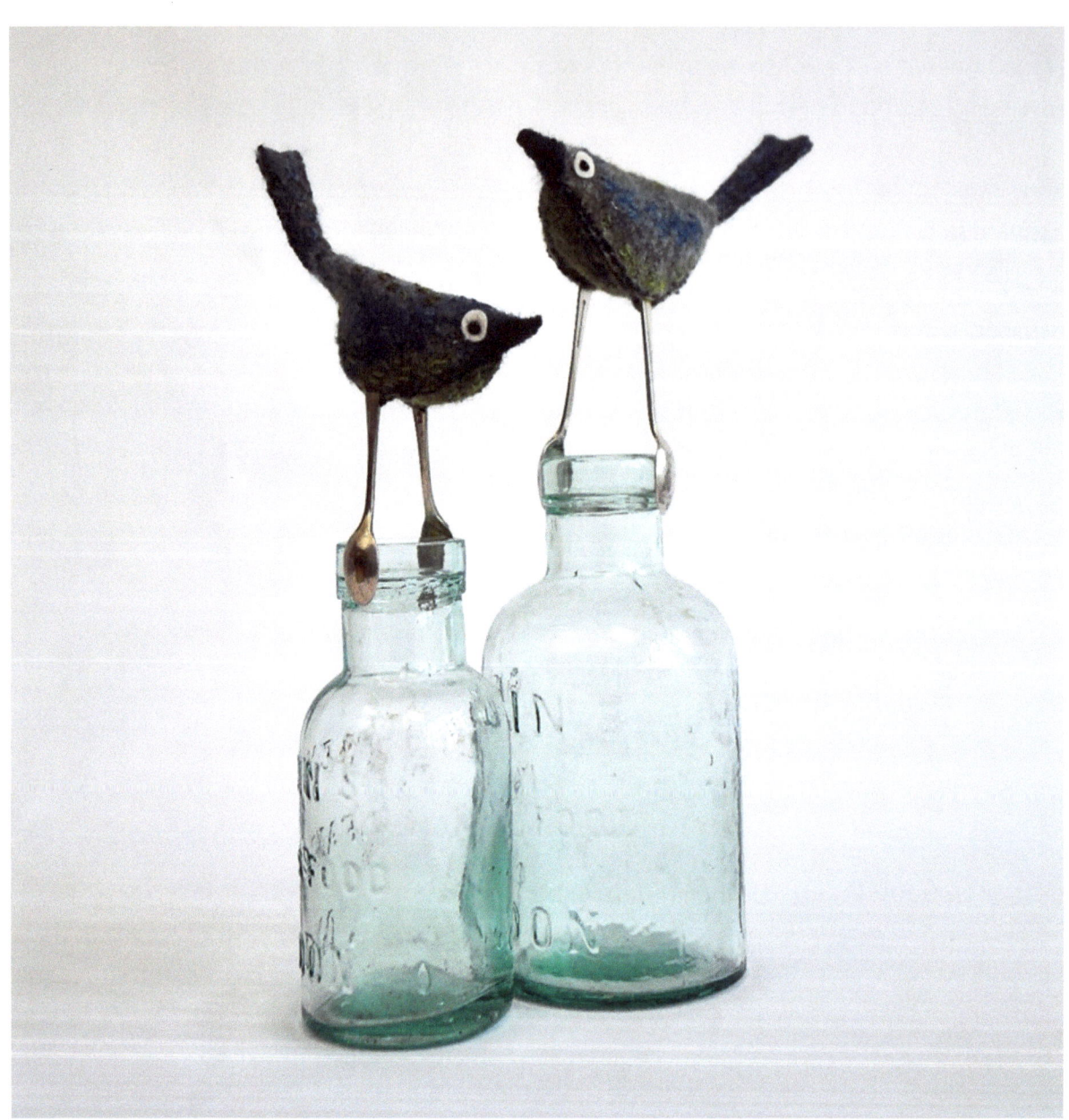

Naomi Beevers

Naomi is a textile and mixed media artist looking on the sunny side of life. Born near St Ives in Cornwall, Naomi grew up on Dartmoor and now lives in Surrey. Her work celebrates her surroundings in Surrey whilst still being influenced by her early years by the sea.

Naomi is inspired by the philosophy of celebrating the beauty of throwaway items and creating something of aesthetic value. She works largely with reclaimed and domestic items, transforming them into beautiful objects often with a quirky twist, whilst valuing their original workmanship. Many of the items used will look familiar and spark memories of the past. Birds are often placed looking out on life with a sense of innocence and humour. Her current collection features familiar birds and fish.

Through the use of everyday found objects personal memories are rediscovered, reimagined and reinvented.

Naomi is based in Guildford.

Image: *Early Birds*, mixed media, 2016.

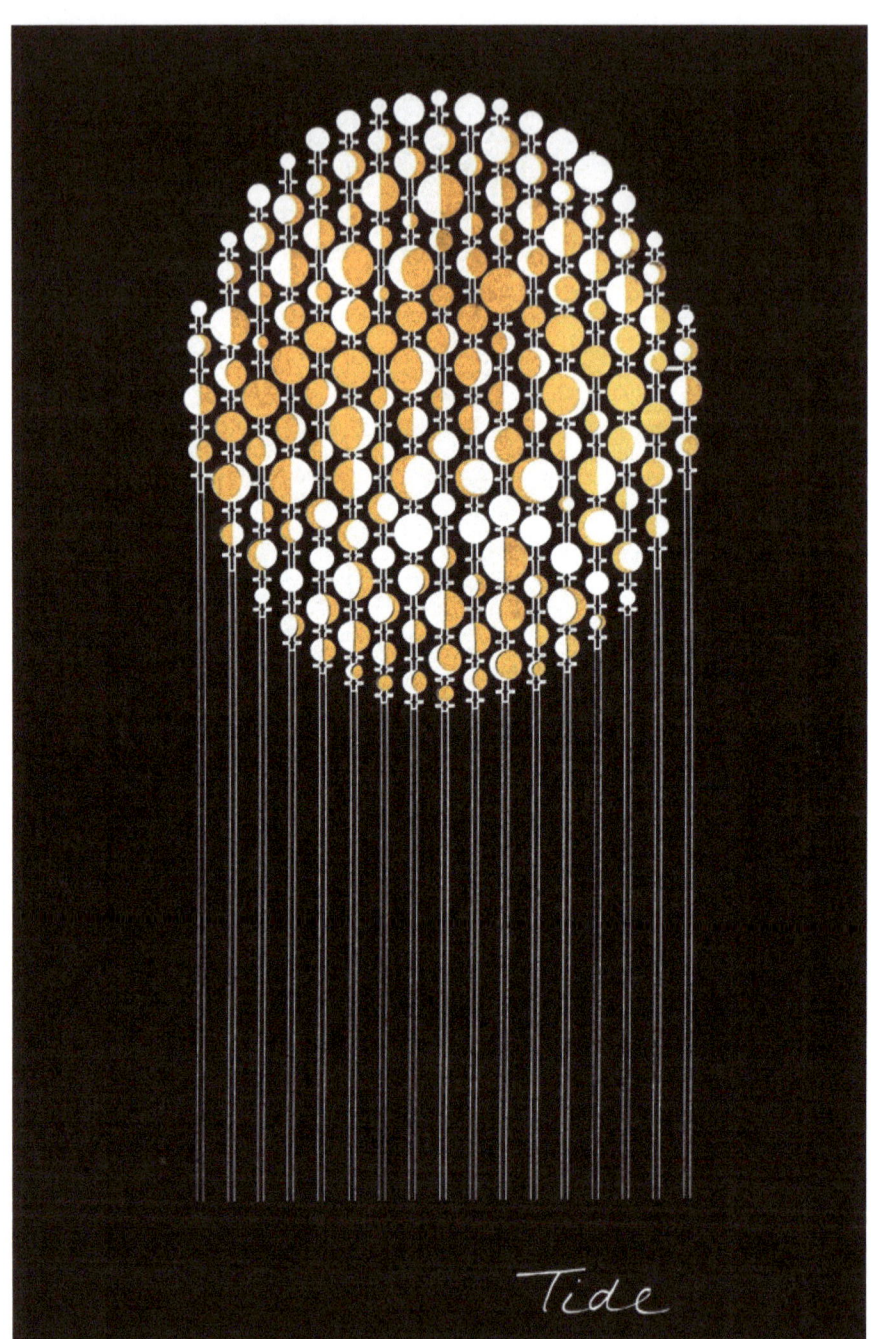

Mary Branson

Mary is a practicing artist of fifteen years and specialises in creating large scale installations, using sculpture, light and sound. Mary uses familiar objects and materials to experiment with scale, light, colour and multiplicity.

Many of her installations are temporary, thus projects can encompass elements of performance, photography, film and sound as forms of documentation. Mary also produces other works in print and ceramics.

Throughout Mary's career, she has been a freelance fine art lecturer at universities and colleges in the UK. In March 2014 Mary became Artist in Residence at the Houses of Parliament, researching the archives of the Suffrage movement, with a brief to produce a proposal for a new permanent artwork for the Palace of Westminster. This artwork *New Dawn* was unveiled in June, 2016.

I try to form new environments that are stimulating, playful, and questioning of the existing polemics of art and the space it inhabits.

Mary is based in Woking.

Image: *Tide*, screen-printed, Somerset velvet 'Black' 280gsm, Lascaux Ink.

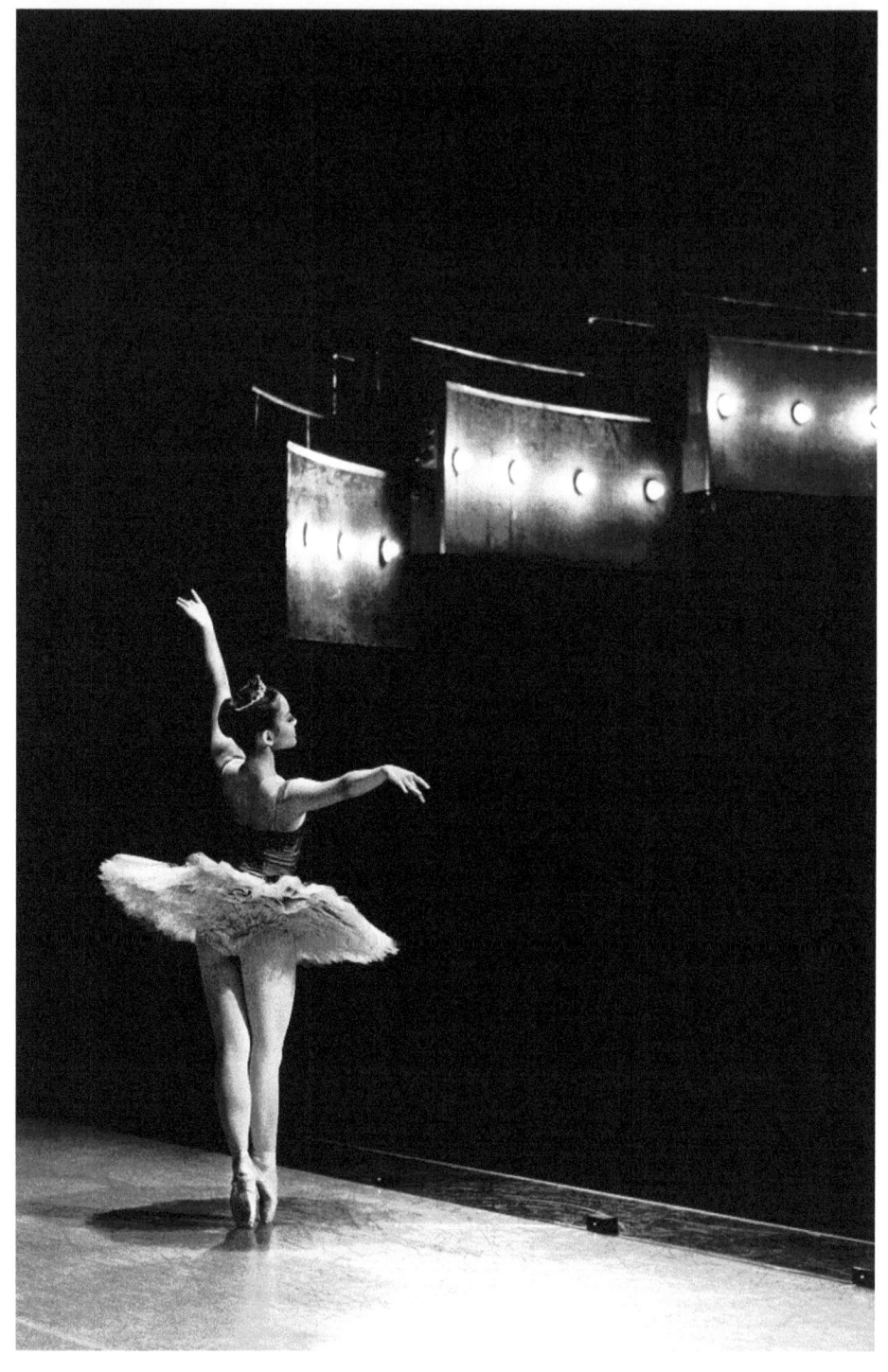

Alex Freeman

As a photographer, Alex has an alternative eye, a unique perspective, and a distinctive style. Rather than produce obvious or expected results, she delivers an exceptional, personal angle to each subject. As an individual, she has a captivating personality, strong interpersonal skills and an ability to see beauty in the everyday ordinary - all of which influences her photography.

Her work is varied and her strength lies in her versatility as a photographer and her ability to connect with others. Irrespective of what she photographs, Alex adopts a celebratory approach and delivers images with a strong narrative that captures the essence of her subject within a single frame.

 Alex works as a portrait, events and stills photographer for a range of private and corporate clients, and welcomes commissions.

I'm looking to capture the extra-ordinary within the everyday ordinary, to celebrate rather than merely record what I see.

Alex is based in Pirbright.

Image: *End of Year Performance - Central School of Ballet*, Giclée fine art paper (Hahnemühle smooth), 2012.

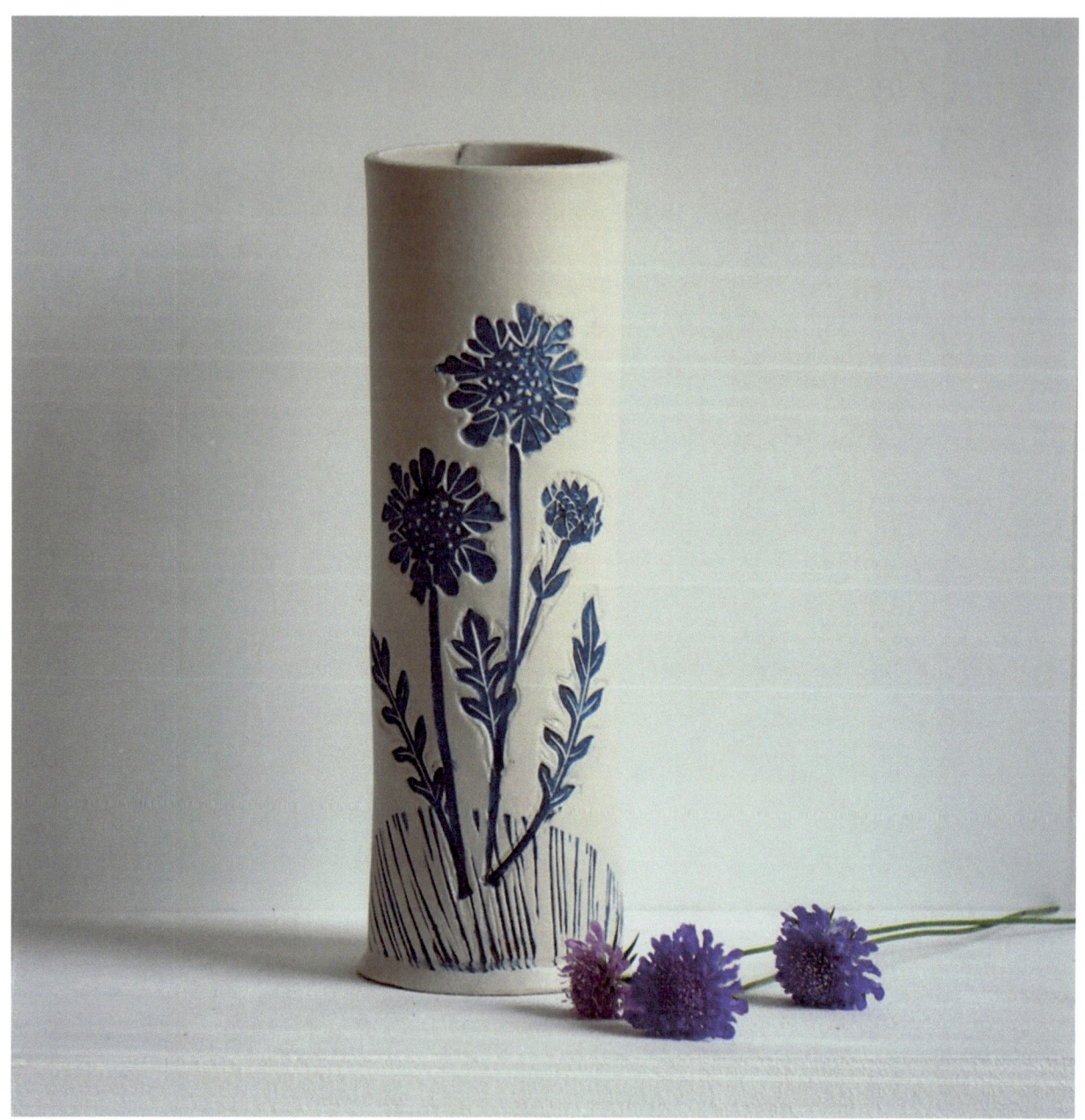

Emma Godden

Emma is a ceramic artist and teacher. Her inspiration comes from nature, such as wildflowers and seed-heads found while walking in her local countryside, as well as plants and birds in her garden. She also has an interest in botanical drawings; although scientific, they are not exact representations, instead they show the details of a plant through the eyes of the artist, much like what Emma aims to capture in her work.

To create her cylinder vases, Emma combines lino printing with clay. She enjoys the process of starting with a sketch, adapting the design into positive and negative and then carving it into the lino, before rolling on the colour (a combination of metal oxides and ceramic stains) and pressing the lino cut into the soft clay. Emma hand sculpts garden ornaments including poppy seed heads and has developed a bronze glaze which highlights their shape and catches the sunlight. These are fired to a high stoneware temperature to ensure that the pieces are frost resistant. All of Emma's pieces are made by hand in her garden studio.

To fully appreciate the tactile nature of my work and the impressed relief of the lino, my pieces should be picked up and handled.

Emma is based in Hindhead.

Image: *Field Scabious Cylinder Vase,* 2017, ceramic – stoneware. Photo: Emma Godden.

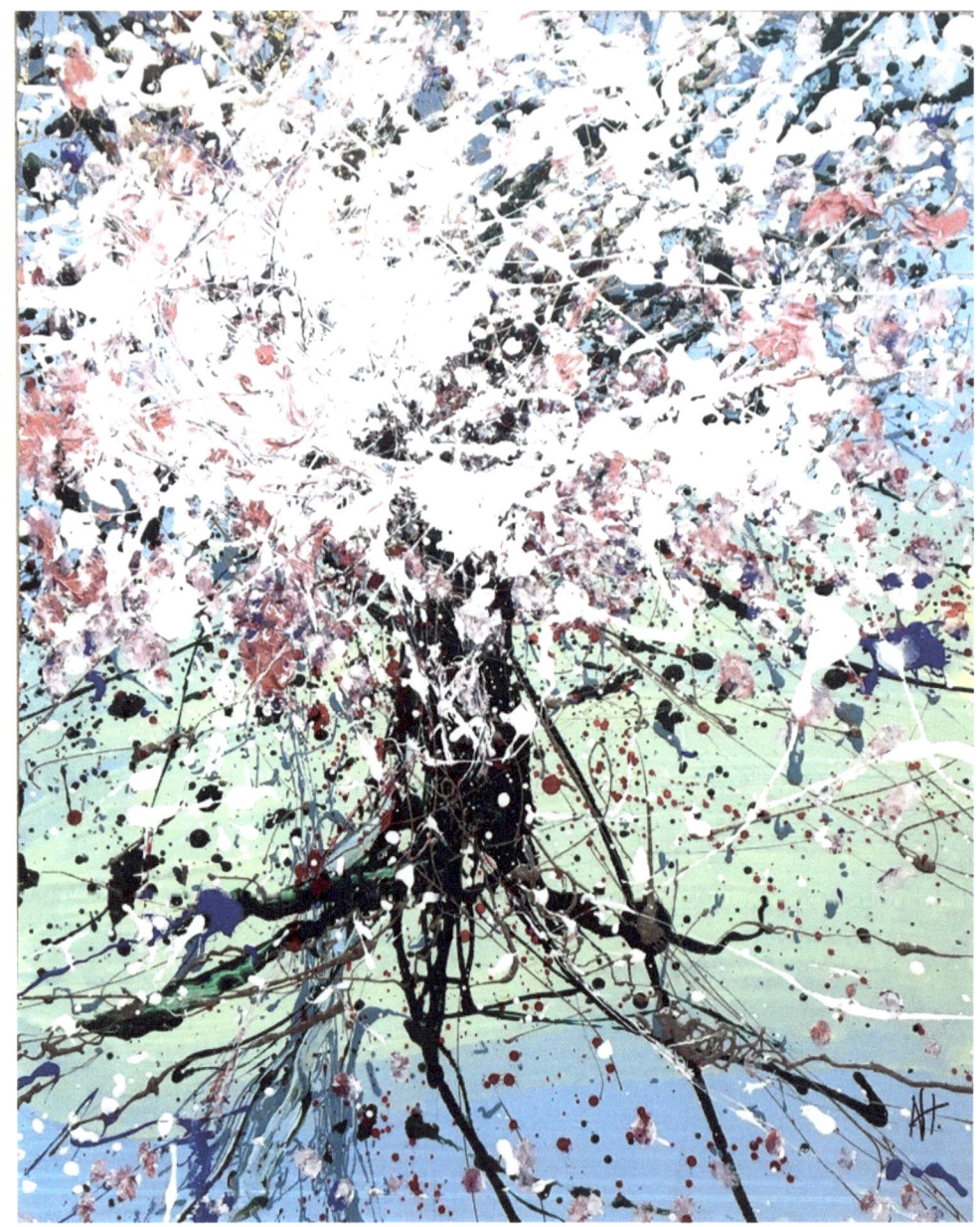

Niki Hearnshaw

Niki's creative journey began during her early years in Africa, drawing with bamboo cane in mud. She has enjoyed exploring a variety of techniques and media ever since. As a national gymnast in her teens, she was exhilarated by movement, energy and life forces - all of which are consistently reflected in her work.

A commissioned artist, Niki studied at UCA Farnham and is now based at her home studio in the town. Building on her successful ranges of vibrant range of acrylics, watercolours and mixed media pieces including Ink on Stone, Niki is excited to launch a new collection of Bronze sculpture. Niki's work has received popular acclaim locally, nationally and internationally, displayed in private and corporate collection worldwide.

Art is a constant exploration, and often a terrifying one. It can draw upon your deepest spirit before lifting you to a higher place.

Niki is based in Farnham.

Image: *Blossom Storm*, gloss, acrylics, inks, on board. Mounted, aluminium frame.

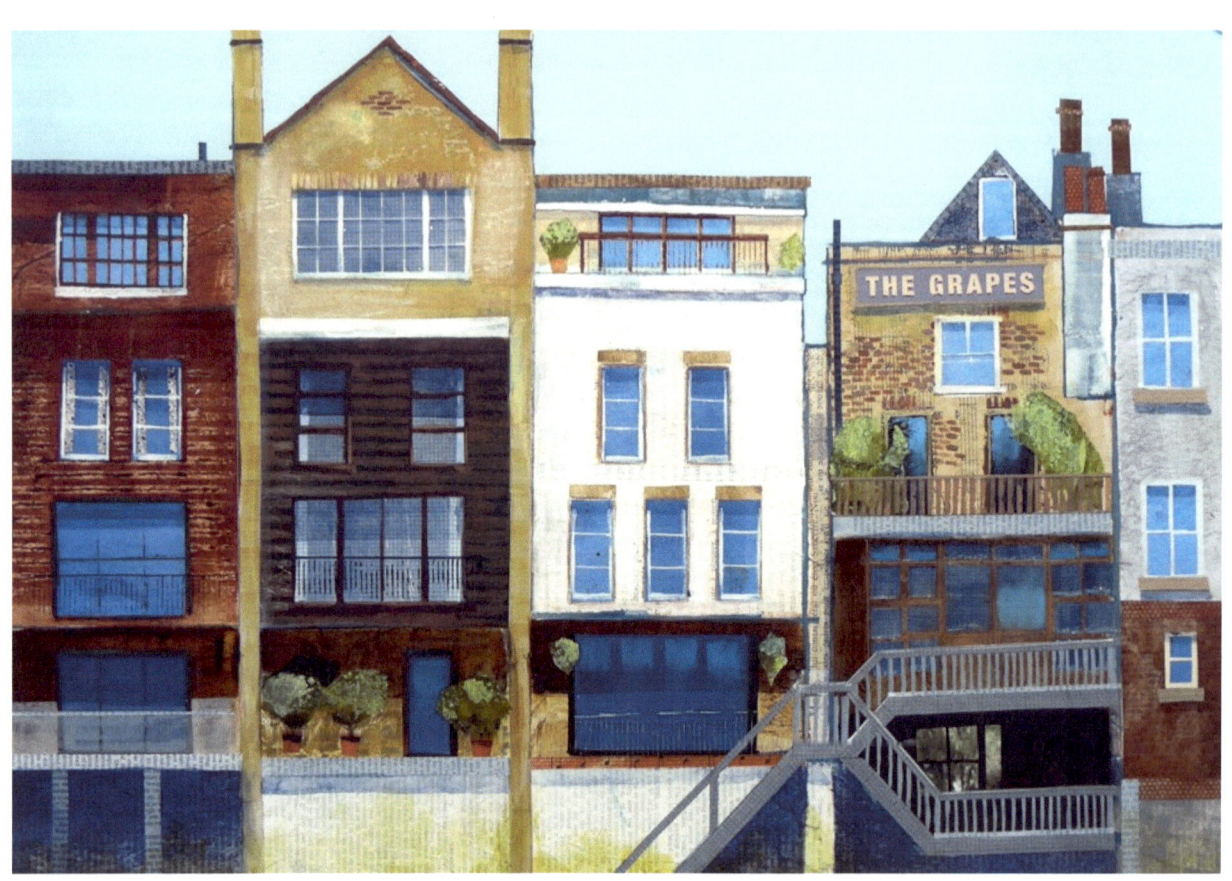

Christine Hopkins

Christine is a painter and printmaker who enjoys working in mixed media. The use of collage is evident in much of her work; working with acrylic inks and wax crayons, she uses her printmaking experience to add layers of texture and detail to her finished work. The contents of the recycling bin are often incorporated, although she will often hunt out relevant paper ephemera to use as background to the drawn structural framework which forms the backbone to all her work. Her love of strong linear form leads often to the addition of scaffolding or other street objects like telephone poles and wiring.

It delights her if a viewer recognises the landscape of a painting, as many of them are entirely works of fiction, drawn from careful observation and memory of many places rather than one specific location.

Working in mixed media gives me a child-like pleasure – I'm able to be creative without being bound by technicalities, making imaginary worlds on paper.

Christine is based in Reigate.

Image: *The Grapes*, mixed media, 2017. Photo: Christine Hopkins.

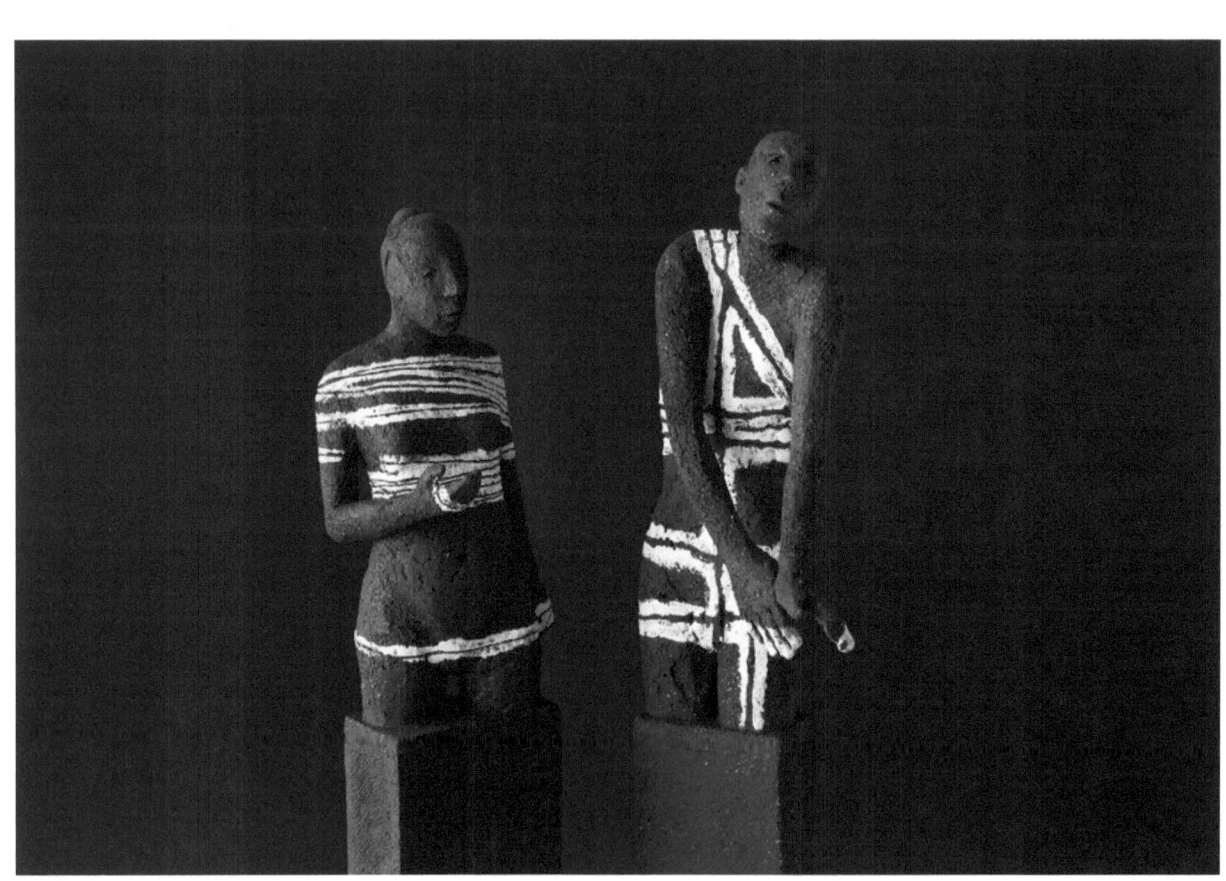

Su Jameson

Su makes one-off hand built ceramic sculptures that are mostly figurative in form. Each piece comes from personal experience but she tries to explore ideas that are both particular and universal. The work aims to be thought provoking and invite reinterpretation.

The body of work shown for the first time at Surrey Artists' Open Studios was conceived during a period of significant change; young people near and far moving on, preparing for life's instabilities, and searching for their place in the world. Some, with guiding parents loosening ties but remaining that all important constant, while others having to go it alone. However, 'family' can take many forms, thus optimistically, partnerships and groups are prevalent in the work.

Alongside the figurative pieces there are vessels, often made as a form of meditation and designed as aesthetic rather than functional objects.

My present work is to do with family; the various roles within it, the physical and emotional ties and that tricky tightrope we walk between protection and liberation of ourselves and others.

Su is based near Liphook.

Image: *Tied,* 2017, ceramic - textured black clay with white slip. Photo: David Weightman.

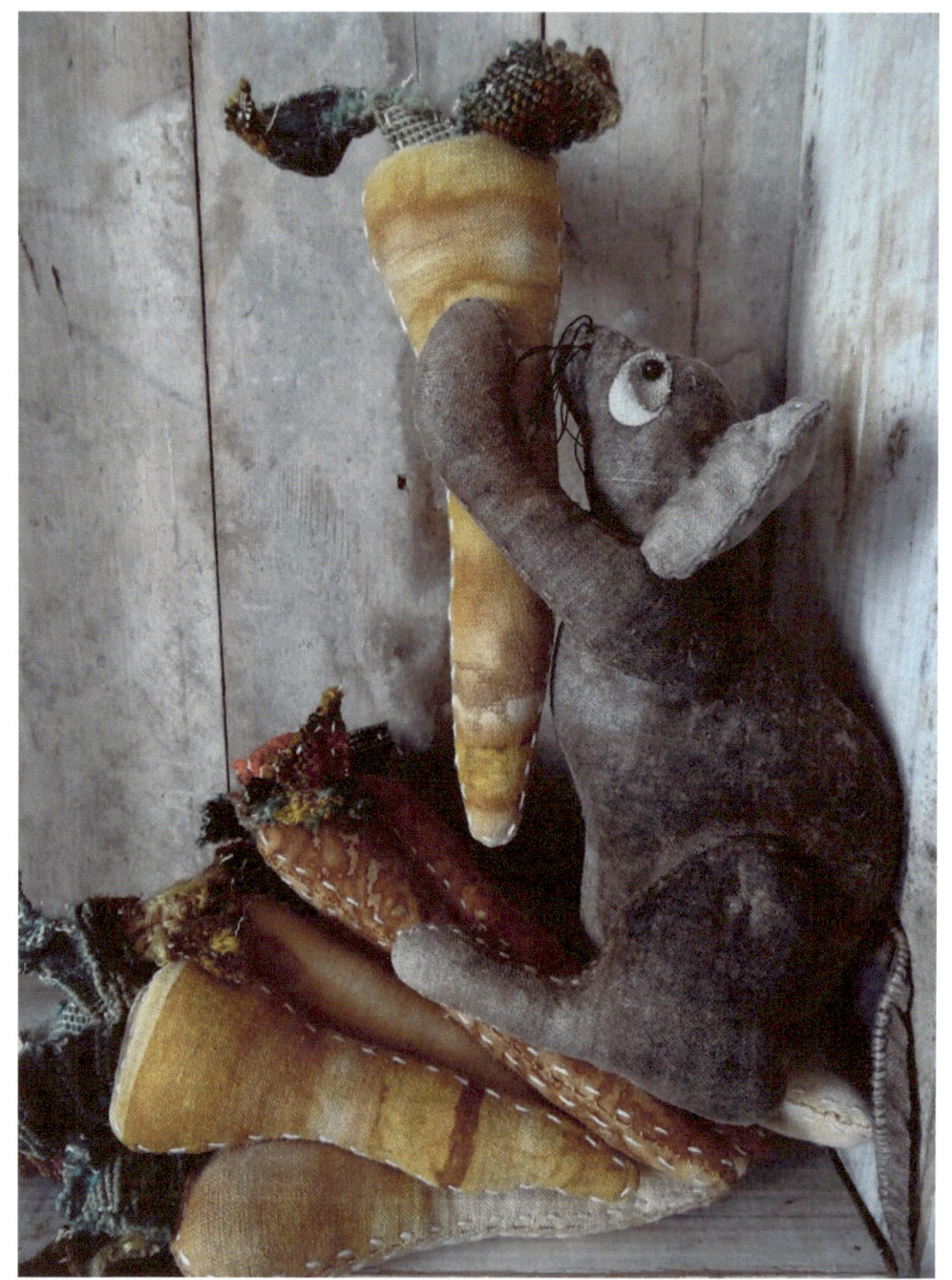

Jule Mallett

Equipped with a camera, Jule is the person taking photographs of rust and peeling paint. Often at her happiest rummaging through battered cardboard boxes she is always drawn to the domestic. Nothing Jule uses is pristine, every surface of her work narrates its own passage through time.

Combining print, thread and rust Jule creates original pieces which reflect her love of the worn and imperfect. Whether drawn, dyed, painted, printed or stitched each piece encourages the viewer to re-examine their own relationship with the old, damaged and mundane. She describes her work as 'handmade, less ordinary'.

Recently, Jule's focus has returned to her first love, hand stitch and rust. Pieces often start from a vague notion and evolve serendipitously as maker and cloth share an unspoken dialogue. Often several pieces are in progress each sharing the same shelf until it finds its own voice and whispers proceed. Some pieces are never finished. They become old friends, observers of their descendants.

Whether drawn, painted or stitched I hope my pieces evoke a sense of playful charm and nostalgia encouraging others to reconsider their relationship with their own old imperfect and mundane.

Jule is based in Guildford.

Image: *All hail the Carrot King*, objet d'art for grownups, hand stitched mixed media.

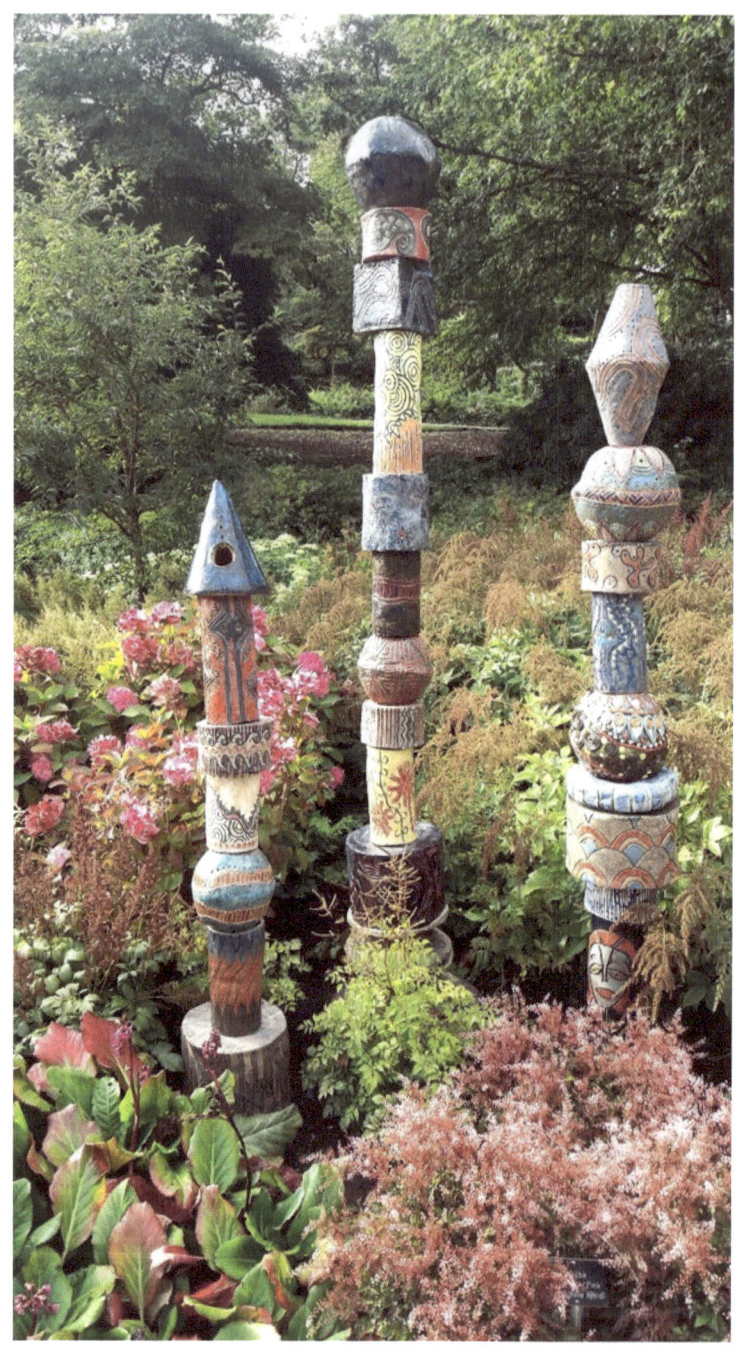

Katie Netley

Katie is a ceramic story teller, which manifests through creating personalised totem pole sculptures. She loves to learn about different cultures from far and wide, allowing her observations to inspire her sculptures; the raw celebration of ritual, the significance of dreams and geometric recurring patterns are all themes she explores within her work. Katie's recent works have been focused on exploring the influences of totemic tribal artefacts.

Katie undertakes private commissions and likes to spend time with clients exploring and translating their ideas into totem pole sculptures. The sculptures are weather proof and are suitable to be placed in the garden. Family tree totems have a section for each member of the family, each section is personalised. The sections are stacked on top of each other to create a wonderful family tree totem. Often the top of the pole is finished with a flower motif.

My exuberance and zest for life naturally transpires into my sculptural works with liberal use of bright expressive colours, representations of organic life and voluptuous female form.

Katie is based in Godalming.

Image: *Ceramic Storytellers,* ceramic.

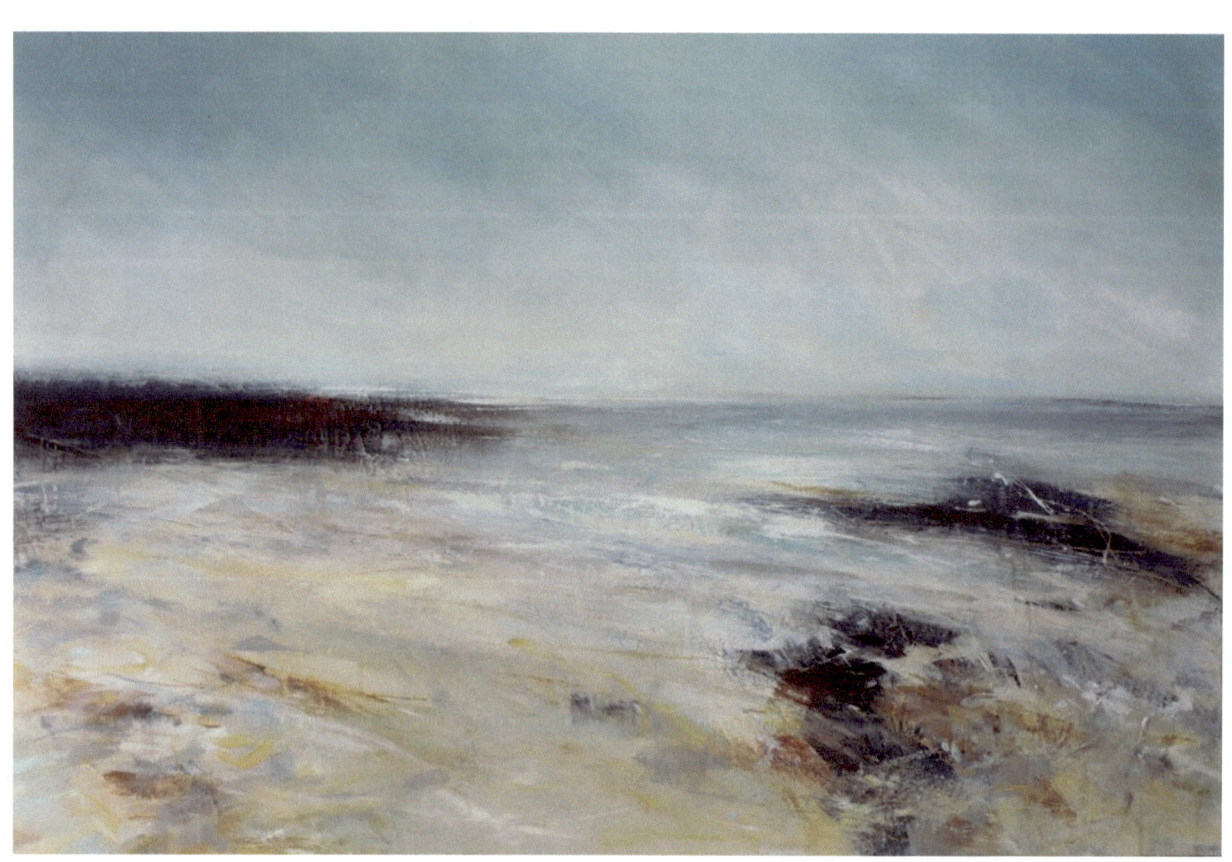

Alison Orchard

Alison enjoyed success as a commercial illustrator and designer, before launching her fine art career. Inspired by nature and passionate about painting, Alison paints directly from the landscape, both at home and on the Cornish coast. She uses these initial experiences to inspire the large gestural paintings created in her Hampshire studio.

Her curiosity with layered surfaces and marks have led her to explore various media, painting with oil or acrylics and more recently encaustic wax, often combined with metal filings, marble dust and coloured charcoal. Her paintings have a vitality that translates directly from the energy of her brushstrokes. There is a play of light built from layers of atmospheric glazed colour. The end result is her reaction to the landscape, expressing humility and wonder at the overwhelming forces of nature.

I have been studying changing landscapes, the sketched lines on the sand, cloud movements, the tidal shift; trying to tell that story and bring that energy into my paintings.

Alison is based in Grayshott.

Image: *Sunbleached Sands*, mixed media on panel, 2017.

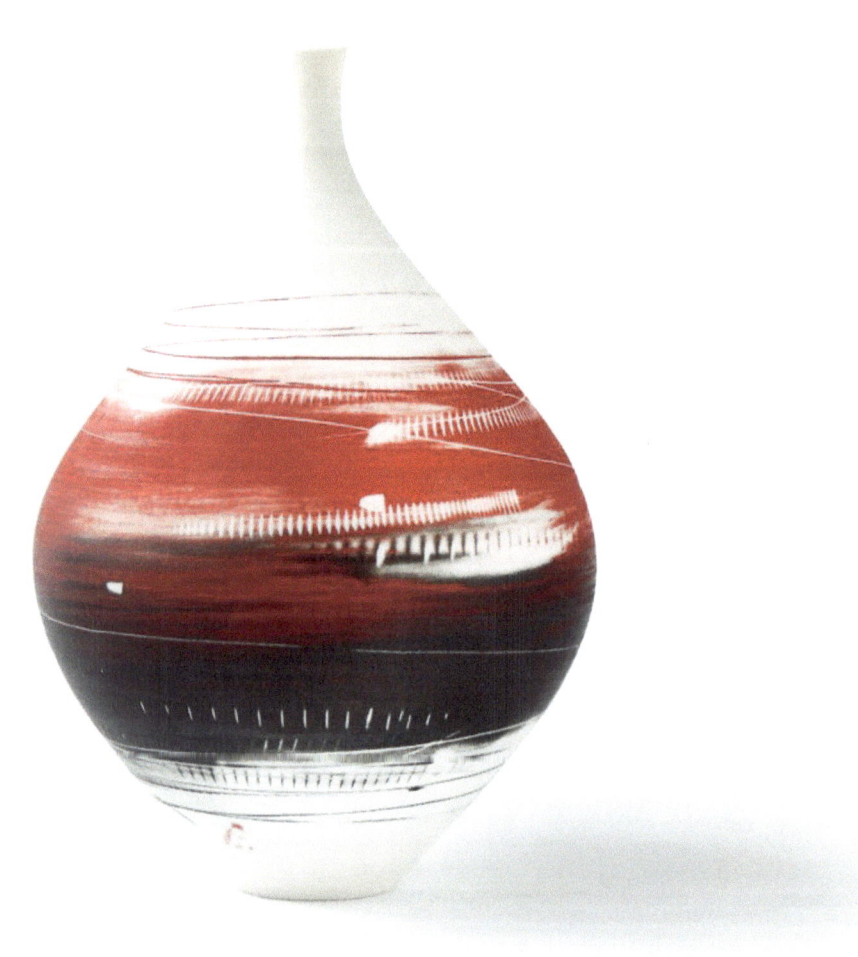

Ali Tomlin

Ali has long had a love of drawing and designing, inspired by the energy of random lines or marks, whether from a sketch, painting, found on stones or peeling paint. She enjoys how a simple line or mark can completely alter a piece.

Ali's work is a collection of thrown, uncluttered porcelain forms. Ali throws and turns the pieces to a fine finish, which when left unglazed gives the porcelain a paper-like, tactile quality. This encourages the hand to follow the lines and shape of the forms and feel the indentations made by the markings. Her use of stains, oxides and slips, and techniques such as splashing or sponging away areas and inlaying lines, aim to create imperfect and unpredictable marks.

Ali enjoys working on the wheel, a process that captures the sense of movement and spontaneity, while her palette of strong but muted colours creates a sense of calm.

I like to leave some of the porcelain white, giving me a clean canvas to play with marks, lines and texture.

Ali is based near Farnham.

Image: *Narrow necked bottle red & black*, thrown porcelain.

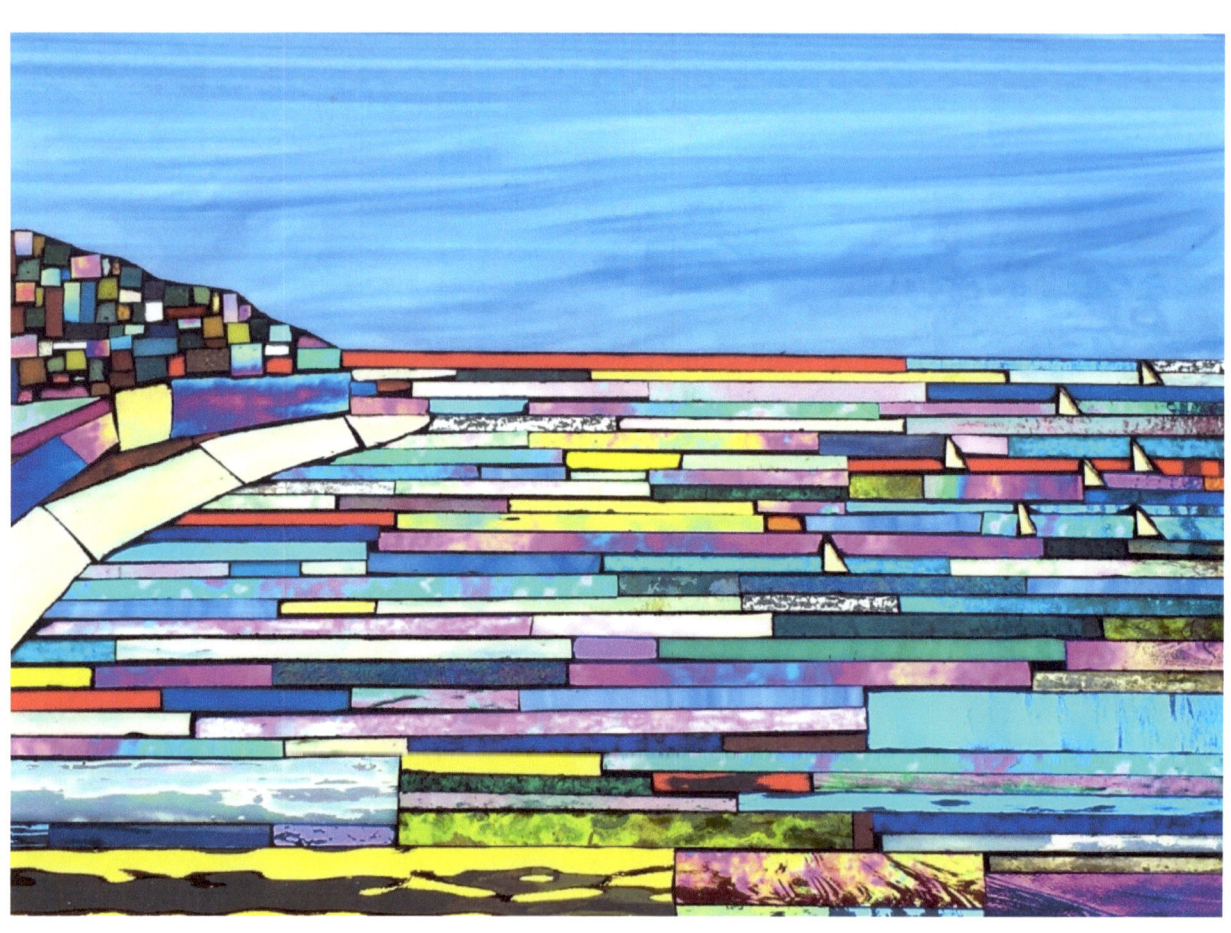

Winner of Surrey Art of the Year 2016

Denise Jaques

Denise is mixed media artist specialising in contemporary mosaics. She creates artwork for interior and exterior spaces. Her work has a strong sense of colour, pattern and rhythm, and plays with the idea of distorted reflections. She is fascinated with the journey of experimentation and excited by the unknown destination.

Her recent artwork relates to places she has lived and loved. Denise has created a series of abstract landscapes and seascapes inspired by the Surrey countryside, Essex coast, and beyond. She uses the reflective qualities of glass to capture the ever changing light on the natural environment.

Denise also creates mosaics for exterior spaces. She has developed her craft to create fun, shimmering mosaic art for the garden. These pieces gently sway, projecting a scattering of ethereal reflections around the exterior space.

Denise Jaques is a member of BAMM (British Association for Modern Mosaics).

Image: *The Pier*, mixed media mosaic.

www.ingramcontent.com/pod-product-compliance
Lightning Source LLC
Chambersburg PA
CBHW041302180526
45172CB00003B/933